Animal Beauty

Animal Beauty

On the Evolution of
Biological Aesthetics

Christiane Nüsslein-Volhard

illustrated by Suse Grützmacher
translated by Jonathan Howard

The MIT Press
Cambridge, Massachusetts
London, England

First published as *Die Schönheit der Tiere: Evolution biologischer Ästhetik* in the series De Natura (edited by Frank Fehrenbach), which is part of Fröhliche Wissenschaft at Matthes & Seitz Berlin: © MSB Matthes & Seitz Berlin Verlagsgesellschaft mbH, Berlin 2017. All rights reserved.

This book was set in Dante MT Pro by the MIT Press. Printed and bound in the United States of America.

Library of Congress Cataloging-in-Publication Data

Names: Nüsslein-Volhard, C. (Christiane), author.
Title: Animal beauty : on the evolution of biological aesthetics / Christiane Nüsslein-Volhard ; illustrated by Suse Grützmacher ; translated by Jonathan Howard.
Other titles: Schönheit der Tiere. English
Description: Cambridge, MA : The MIT Press, [2019] | Includes bibliographical references.
Identifiers: LCCN 2018042911 | ISBN 9780262039949 (hardcover : alk. paper)
Subjects: LCSH: Evolution (Biology) | Nature (Aesthetics) | Sexual selection in animals.
Classification: LCC QH366.2 .N8913 2019 | DDC 576.8—dc23 LC record available at https://lccn.loc.gov/2018042911

10 9 8 7 6 5 4 3 2 1

Contents

I Evolution and Aesthetics

Nature offers herself to us in many guises; what she hides, she at least hints at; she provides rich material for both the scientist and the philosopher, and we would do well not to scorn any means that may help us to observe her more closely and study her inner mechanisms.

Johann Wolfgang von Goethe, 1832

1

Humankind finds the colors, patterns, and songs of animals beautiful, just as we do paintings and music. Our works of art are created by humans for humans, but what about the wonderful works of nature, the ornaments and sounds of animals, and the variety of colors and patterns of flowers? How do they arise? Why and for whom are they here?

Biologists do not discuss beauty as an attribute of living things. The serious scientist will not apply the term "beautiful" to shapes, colors, or sounds, because beauty is in the eye of the beholder, connected to a subjective sensibility that may indeed be aroused by the physical properties of beautiful objects but nevertheless cannot be measured. And yet the beauty of plants and animals, as we experience it, fulfills a similar function in nature as does art in human culture.

Even in prehistoric times, humans, being rather ill-endowed with natural ornamentation, adorned themselves with feathers and skins of other animals, thus achieving versatility of coloration through art and artifact. Other animals cannot do this, but rather display shapes and colors corresponding in each species to its own way of life, and these, as with humans, are recognized by their congeners and used for communication. How these colors and patterns arise, and how they function in the social life of animals, will be sketched in this essay. Only a few key examples will be described in detail, both because there is an almost unlimited number

of possibilities to choose from, and because the amount of information available for each case is not the same. Color patterns have not been researched with high priority because they appear as nonessential luxuries, unlike for example the structure of limbs or the mechanisms underlying organ function. Color patterns generally arise rather late in the life of an animal, and their development is largely inaccessible to direct observation. How insects, beetles, flies, and butterflies develop their colors is reasonably well known, but in vertebrates much about it is obscure. In mammals and birds, critical steps in the development of color patterns are established quite late, and they are hidden either in the mother's belly or in the bird's egg. We do, however, now know a lot more about these processes in fish, and at the end of this book the development of the characteristic stripe pattern of the zebrafish will be described in some detail.

Evolution

Charles Darwin proposed that animals, like humans, evaluate ornaments and songs on the basis of their subjective sensibilities and their cognitive experience. Such evaluations could lead to the evolution of attractive characteristics that are not in themselves

functional, but are essentially arbitrary and in this sense differ fundamentally from other selectively advantageous physical characteristics.

Darwin is the founder of modern biology; what was new was his explanation of the characteristic features of animals and plants in terms of natural processes, without the intervention of the supernatural. His biology left no room for a Creator. His theory of evolution laid down the fundamentals of our present understanding of nature, and in the nineteenth century it caused a revolutionary transformation in our perception of our place in nature.

As a young man Darwin spent five years on a journey around the world; he watched and he listened, he examined cliffs and mountain ranges, and with enormous curiosity and a penetrating interest he observed and collected a myriad plants, animals, and fossils. In the meantime, much of that great natural diversity has disappeared; however, Darwin had much more direct access and closer contact with nature than we can have today. The description of newly discovered plant and animal species was a major theme in the biology of that time, an activity that has long since almost come to an end.

Three key observations on his journey convinced Darwin that not only the geology of the Earth changes over the course of time, but also that there is biological evolution. He recognized:

- the similarity between the (small) living and (gigantic) extinct fossil forms of armadillos in South America;

- the division of the ostrich-like nandu (rhea) into geographically distinct subspecies; and

- the relatedness between the unique animal and plant species on the volcanic Galapagos Islands, species that were apparently derived from those on the neighboring South American mainland.

Very shortly after returning, Darwin formulated natural selection as the mechanism by which species change, but it took a great deal of further research and information until he finally published his great book, *On the Origin of Species by Means of Natural Selection, or The Preservation of Favoured Races in the Struggle for Life*, in 1859. In *Origin of Species* Darwin describes how the improved chances of survival of better-adapted individuals gradually lead, over millions of years, to changes in form, to the origin of new species, and to the extinction of others. The theory of evolution by natural selection has been completely confirmed through the molecular analysis of genes and is now no longer disputed.

A species is a group of organisms that recognize their own kind, accept each other as sexual partners, and are capable of interbreeding. Evolution, the capacity for change in a species, arises from two general characteristics of living things.

1. Variation. Individual members of a species are not absolutely identical; rather, they differ slightly from each other in many respects, including in behavior. These variations occur spontaneously and without any direction but are frequently heritable. That means that these characteristics are transferred to the offspring, and any that turn out to be advantageous can be passed on to future generations.

2. Surplus. To maintain population numbers, it is formally sufficient if each couple produce two progeny. However, more, often very many more, are produced than can survive. This compensates for the loss of those progeny that do not reach the reproductive age. If there were no death before reproduction, a population would grow exponentially in proportion to its existing size. Normally, this growth is limited by unfavorable environmental conditions such as disease, predators, cold, heat, shortage of food, or drought.

Darwin proposed that the large number of offspring favors the survival of those individuals that thrive better than their siblings in the prevailing environment. The variation between individuals means that some will be better adapted than others to any change in the conditions of life, and thereby gain a survival advantage. Thus if the prevailing temperature falls, individuals with thicker fur are better off, while rising temperature favors

lesser hair growth. The better-adapted individuals, being more successful in the struggle for existence, produce more offspring. Because improvements in adaptation are heritable, over generations the average constitution of the population, in other words of the species, will unavoidably change. This principle of evolutionary change Darwin named "natural selection."

In a later book, *The Variation of Animals and Plants under Domestication*, published in 1868, Darwin explored the principle of selection in domestic animals and cultivated plants. In the breeding of animals and plants, the subjective taste of the breeder plays the decisive role. It is astonishing in how short a time the selection of specific variations can lead to dog breeds and rose varieties with widely differing novel characteristics corresponding to the breeders' aesthetic sense, so long as the breeder selects for specific criteria rigorously enough. During selective breeding, generally quite striking individuals are selected that can survive only in the protected environment as pets, garden flowers, or cultivated plants; they would have hardly any chance of succeeding in the wild.

With his theory of evolution, Darwin clarified innumerable and, until that time, difficult to understand problems. He also realized that the genetic relationship between species, based on common ancestry, effortlessly explained the classification of animals and plants according to the "natural system" of Linnaeus

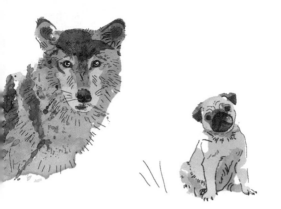

All the dogs in the world (*Canis lupus familiaris*) are descended from the wolf (*Canis lupus*).

(*Systema Naturae*, 1735). This system attempted to classify animal and plant species according to morphological criteria. At that time scientists generally wrote about the similarities between species, and the natural system of classification, as the plan of the Creator. In contrast, Darwin's theory explained such similarities in terms of common ancestors: "All true classification is genealogical; community of descent is the hidden bond which naturalists have been unconsciously seeking and not some unknown plan of creation." The famous single illustration in *Origin of Species* makes this argument clear: the family tree is really a bush with multiple branchings reaching upward to the present. The tips of the branches are the species alive today, grouped according to

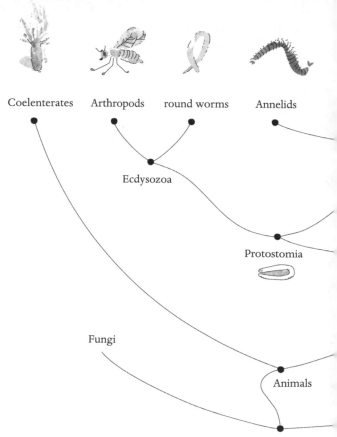

Coelenterates Arthropods round worms Annelids

Ecdysozoa

Protostomia

Fungi

Animals

Protozoans

The family tree of the animals. The bauplan (generalized structural organization) of animals is seen more clearly in early developmental stages that are not yet functional than in the adult. For this reason, classification criteria are often derived from embryonic or larval characteristics. Animals alive today can be divided according to their bauplan into about thirty-five groups (phyla). The great majority of

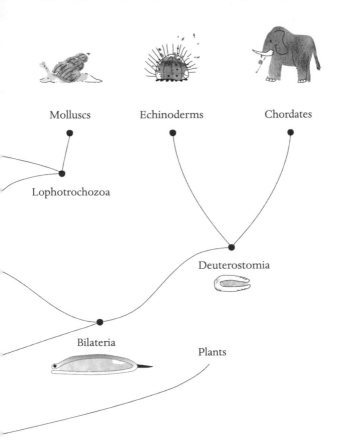

Molluscs Echinoderms Chordates

Lophotrochozoa

Deuterostomia

Bilateria

Plants

these groups, including the arthropods (with the insects) and the chordates (to which vertebrates belong), are Bilateria, which have upper and lower surfaces and right and left sides, in contrast, for example, to the radially symmetrical coelenterates (sea anemones). Probably all the Bilateria are derived from a single common ancestral form.

similarity. Side branches that end before the present stand for species that have gone extinct, and that is more than 99 percent. The branching points symbolize intermediate ancestral forms that have also gone extinct. If all the species that have existed up till now were to come to life, these intermediate forms would reappear. This would then allow an unambiguous classification based on shared descent with modification. Species can persist virtually unaltered over long periods of the Earth's history; examples are the coelacanth, the horseshoe crab *Limulus*, the sturgeon, and also plants such as ferns and monkey puzzle trees, *Araucaria*. Organisms can also change dramatically during the course of the history of the Earth; new species can come into existence through splitting of the parent species, perhaps as the result of a geographical separation. Famous examples of this process are the Galapagos finches, which Darwin himself described, or the cichlids of the great African lakes. The forefathers of the currently living species are therefore not other living species, but common ancestors, which no longer exist today. Thus humans did not arise from chimpanzees, but the two species have a recent common ancestor. All species now alive are descendants of earlier evolutionarily successful types. All the great animal groups (Metazoa) alive today have been evolved during the course of the Earth's history from one original type.

The beaks of the finches on the Galapagos Islands have adapted to feeding on different types of food, such as seeds or insects.

In Darwin's time and indeed for a long time afterward it was debated back and forth if and to what extent the lifestyle of a creature could cause heritable variation, whether the effects of experience or learning could be stably transferred to offspring and thus contribute to the modification of species. Darwin himself, however, postulated correctly that variations are accidental, arbitrary, and undirected, even though the root causes of mutation, the logic as well as the molecular basis of inheritance, were completely unknown. Gregor

Mendel had discovered, and published in 1866, his famous laws of inheritance of characters in plants (sweet peas) but they were not noticed for more than thirty years and it took another two decades before their relevance to the Darwinian theory of evolution was clarified. Chromosomes were known, but the "chromosome theory" of inheritance was originated by Theodor Boveri only at the beginning of the twentieth century, when the Mendelian laws were confirmed for animals by Thomas Hunt Morgan's experiments with the fruit fly, *Drosophila*. Today we know that the structure of genes, the deoxyribonucleic acid (DNA), contains a molecular encryption, a code, that determines the inherited characteristics. Heritable variations, mutations, arise from changes in the DNA caused by unavoidable reading errors during DNA replication at cell division that may affect the way a gene functions. Most mutations have negligible effects on the organism; they are effectively neutral. Some mutations are harmful and cause more or less disadvantage to the individual. However, in rare cases, mutations may under some environmental conditions turn out to be advantageous. Such drastic variations arising from selective breeding as double-flowered roses, the short legs of dachshunds, and the white fur of albino rabbits are usually the result of mutations causing loss of function of specific genes. On the other hand, variations that play a role in evolution, for example longer or shorter or

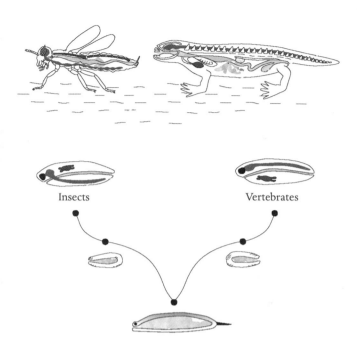

Insects compared with vertebrates. In a comparison between the bauplan of insects and vertebrates, it appears as if the relative positions of the main organs are inverted; the nervous system of vertebrates, the vertebral column, is on the upper side of the body, while in insects it is on the lower side. The position of the heart is also inverted. These alternative arrangements arise at an early developmental stage through an invagination in the embryo surface called gastrulation (development of the intestine). The position of the invagination will determine whether it develops into the mouth (Protostomia) or the anus (Deuterostomia).

lighter or darker hair, are caused by small changes in gene function. Species thus evolve over many generations through many mutations with small effects. There is today no reasonable doubt as to the truth of Darwin's theory of evolution.

Beauty

When Darwin published his theory of evolution by natural selection, one of the main criticisms was that beauty in nature, the ornaments, the colors, the birdsong, could not be explained by it; these things seemed to have been designed by a Creator purely

for the pleasure of humankind. These attributes are indeed uneconomical; they are costly to produce, they expose animals to risk from predators, and they have no obvious life-supporting role; in fact, countless examples show the opposite, that they are indeed a handicap, increasing risk, as for example the long and heavy tail feathers of the peacock or the large horns of deer. Darwin recognized the problem and took it up in a further important book, published in 1871: *The Descent of Man and Selection in Relation to Sex*. In this book, which is eminently worth reading, Darwin dealt comprehensively with the theme of Beauty, and did not hesitate to use terms like "a taste for the beautiful," "aesthetically pleasing," and "charming" to denote the sensibility of animals. He did this in the conviction that the colors and ornaments of many animals are also perceived by the animals themselves as attractive and agreeable, just as they are by us: "If female birds had been incapable of appreciating the beautiful colours, the ornaments and voices of their male partners, all the labour and anxiety exhibited by the latter in displaying their charms before the female would have been thrown away; and this is impossible to admit." Darwin also attributed to beauty an important function in the lives of animals. He described the large role that attractiveness plays for animals in the choice of mating partners, and named this "sexual selection." The greater part of the book is dedicated to a detailed description of sexual behavior and especially striking

Birds of paradise present their plumage on a specially prepared lek.

secondary sexual characters across the whole animal kingdom.

Why does Darwin, perhaps unexpectedly, describe partner choice as a special case of selection in connection with the biology and descent of humankind? Humans have neither the fur nor the feathers that other animals can display as ornamental colors. The human integument, excepting head hair, beard, and sparse body hair, is naked and all of a color. Yet appearance, attractiveness, plays an especially important role for humans, as declared by the many ways in which appearance is modified as a cultural attribute.

During his world travels and also afterward Darwin not only collected animals and plants and investigated geological formations, but also thought deeply about the nature and the origins of humankind; later he systematically evaluated the observations of other explorers. On his world travels he encountered people of many different ethnic groups and national types; at that time there were many indigenous groups, aboriginals, "savages," with whom he came in contact, and whose appearance, culture, customs, and ways of thinking he could experience directly. In *The Descent of Man* Darwin argued on the basis of bodily structure that the human species, *Homo sapiens*, undoubtedly belonged to the class of mammals and that no special place needed to be created for humans to contrast with other animals. Even the spiritual and social qualities that distinguish humans such as morality, speech, and tradition have arisen from qualities that can be observed in other animals. Humans indeed differ dramatically in many respects from the "lower" animals, but Darwin writes: "The differences are of degree, not of kind." Darwin therefore speaks not of "humans and animals," rather of "humans and *the other* animals." For many human behavioral characteristics, such as the use of tools, instinctive behaviour, speech, insight, art, the religious and the moral sense, he found primitive forms in the animal kingdom, especially in the apes, but also in birds, dogs, and other pets he knew well.

At that time, it was not at all widely recognized that there is only one recent human species (the dispute between "monogenists" and "polygenists" was related to the widespread practice of slavery, which Darwin loathed). Important experiences for Darwin were his acquaintance with a freed slave who taught him how to stuff birds ("I used often to sit with him for he was a pleasant and very intelligent man"), and the three South American indigenous children who were being returned to their native land on board the *Beagle*. They had been brought to England from Tierra del Fuego as "naked savages" in order to educate them in civilized English behavior. On the journey back, Darwin became fully convinced, "with the many little traits of character, shewing how similar their minds were to ours," that he and they were of the same kind.

In *The Descent of Man* Darwin employed generally accepted principles of classification of species from characters of anatomy, physiology, and development to confirm that there is only a single species of human being, *Homo sapiens* (Carl von Linné, 1758). This means that *Homo sapiens* is one of those rare species that has populated even the most widely divergent environments, from the far North to the deepest South. Humans are extraordinarily flexible, they can live in heat and cold, in mountains, forests, and deserts. With help from cultural progress, especially in the use of fire and tool-making, humans have adapted to, and prospered, in the most diverse

conditions of climate, nutrition, and shelter. This has enabled our species, which arose in Africa two hundred thousand years ago, to spread from there in an extraordinarily short time and populate the whole globe. There is hardly another species that is so widely distributed; without culture, it is virtually impossible.

Geographically separated human groups (races) look very different from one another, but they can freely interbreed. Their differences are only partly adaptations to climate; characters that distinguish the appearance of different races are often completely arbitrary. Light or dark skin and hair color, beardedness and body hair, straight or curly head hair, body form, appearance of nose, lips, eyes, and much more are arbitrary in the highest degree. They are not of any direct or specific value to us, thus not adaptive in the strict sense of increasing our fitness.

Darwin concluded that these characteristics are not primarily important for our physical health or fertility; otherwise they would either have disappeared through natural selection or become uniform in their expression. He explained the existence of this variation in human appearance in terms of different ideals of beauty among the different races. His thesis is thus that whatever is considered beautiful plays an especially important role in partner choice. Different human cultures look different because they are based on different standards of beauty. Darwin wrote "Selection in Relation to

Sex" originally about humans. One of his examples concerned skin color, which is darker in hot countries and contributes to protection against ultraviolet light. But despite similar climates, the natives of the South American and African primary forests have skin colors of different darkness and different hair forms and distribution. Eskimos, who eat fish and are dressed in thick animal skins, differ scarcely at all in their light skin color from those Chinese peoples who live in far warmer climates near the Equator and eat mostly vegetables.

Ornament

An important attribute clearly distinguishes humans from other animals: we decorate ourselves. Darwin noticed that in order to enhance their appearance all native tribes paint or tattoo themselves, make up their faces, and clothe themselves, use jewels and

other artificial ornaments, and sometimes work on modifying the shape and form of their head or body to increase their attractiveness or status. Frequently, these ornaments represent exaggerations of traits viewed as beautiful in the culture concerned. The naked human skin, the loss of the typical mammalian fur coat, invites its decoration, or clothing it with materials that can be ornamented. The artificial emphasis of beautiful characteristics surely has something to do with the fact that humans are self-aware and also conscious of the effect that they have on other people; they look at themselves in mirrors, they are vain. And in this respect, humans are fundamentally different from other animals; perhaps this is indeed a truly unique characteristic that no other animal possesses. Personal knowledge of one's own appearance may have been one of the original drivers of human art. Among the earliest artifacts from the Stone Age are drilled mussel shells that were hung in a chain as a necklace. Shiny gold jewelry was valuable in every culture. A decorated and bejeweled female face today still represents the epitome of beauty.

This culture of self-decoration, of makeup and dress, often using animal products such as skins and feathers, is found in no other animal, because other animals do not inspect themselves; they decorate themselves with no artificial extras, and their ornaments, colors, and shapes are part of their nature; they are inborn.

What was the context for the origin of self-ornamentation? What was responsible for this developmental leap toward humankind? An important invention among hominids is mutual observation, "shared intentionality," when performing activities together. For this, each individual must be aware that the others are observing him, and may also make himself especially conspicuous in order to attract attention. Common activities were hunting, but also tool-making and preparing food at the fire. This developed into an awareness of "I," "we," and "you," and into language. To look attractive is especially important to humans in many social contexts, not only in partner choice.

The face plays a major role in effective communication between people; people look at each other when they talk or do anything together. Correspondingly, cultural ornament is mainly dedicated to the head in the form of face-painting and hairstyling. In many human cultures, the head is ornamented with beautiful animal furs and bird feathers. In other animals, the head and face, and especially the eyes, are often emphasized by color or other form of ornamentation; this decoration functions in mutual recognition within a species. Although many social animals recognize each other's faces individually, in no other animal does the beauty of the face play the same role as it does in humans.

In other animals, striking colors, patterns, and markings are distributed over the skin and its

In many human cultures the head is ornamented with animal furs and bird feathers.

derivative structures; the skin itself, or hair, feathers, and scales show appendages and protrusions that extend across the body and tail. Very often it is the males that are beautiful and the females who drive selection by the evaluation and choice of male sexual partners. Nevertheless the peacock, who is most unjustly considered the epitome of vanity, has no idea how beautiful he is. Beauty is an innate attribute in the species that evokes pleasant feelings in the opposite sex: aesthetically pleasing, "he charms the females." Beauty is perceived by all the senses, through scents, colors, ornaments, songs, or touch.

For the individual, beauty is not necessary for life, but it plays a key role in partner choice and therefore in breeding, which is the necessary

condition for evolution. "Sexual selection" drives mate choice within a species; it is a species-internal selective process, essentially self-selection. Darwin extended his evolution theory with the principle of sexual selection, which, unlike natural selection, works through a participating observer.

Examples of characters that count for natural selection are fur thickness, hair type, beak or tooth shape, dark coloration, and countless morphological and physiological adaptations. Sexual selection, in contrast, works in plants through flower color and shape, and through colors, patterns, and songs in animals. Flowers give signals that allow insects to find plants of the same species again and are therefore important for their pollination, and thus for their breeding success. Wind-pollinated plants, in contrast, have completely inconspicuous female organs. The song of a male bird drives away males of the same species but is recognized and appreciated by females of the same species. Because other animals recognize shapes and colors or songs, these attributes doubtless have important functions in these animals' lives; they contribute to reproductive success, and thereby are of decisive importance in the modification and origin of new species during evolution.

Aesthetics

Color and ornament play a major role not only in partner choice but also in other aspects of social behavior. From head to toe, the appearance of humans is culturally modifiable and important for many social interactions, as shown by the multiple

In many bird species only the males are colored, whereas the females are less conspicuous while breeding.

uniforms, decorations, masks, and tribal dress used for rituals, dances, games, and war. For other animals such aesthetic characteristics are entirely inborn, genetically determined, but can to a degree be influenced by an animal's behavior, strengthened, revealed, or concealed. These attributes work as communication signals, since their function depends on an observer, that is, on the subjective visual perception by another individual. These signals are recognized and stimulate an appropriate response. One may consider this aspect of sexual selection as a special case of a more general "aesthetic selection" because of the cognitive function involved in social communication. Choice is determined by the subjective sensibility of an observer.

A special feature of these aesthetic characteristics and of their function in the life of animals is that the

The frog is as green as grass; the eyespot on the wing of the butterfly deceives the enemy.

receiver of signals must both recognize them and set a value on them. These abilities can be acquired early in life (by learning or imprinting) or may be inborn. Coevolution follows, a reciprocal developmental process between the signal sender and the receiver who evaluates the signal. This process of "evaluative coevolution" occurs in every kind of biological communication, and also in human creative arts. Biological aesthetics, like art, is a form of communication that changes continuously through the constantly evolving judgment of the observer. Many animals have highly developed eyes, can perceive subtle details in images and shapes, and have the ability to commit these differences to memory. In fact there is no particular quality of any human sensory system that is not surpassed in at least some animal species. From the original function

of pigments and coloration to protect the sensitive bodies of animals from sunlight, there emerged during the course of evolution many colors and patterns that could be perceived by other individuals and serve for social communication.

Almost all animals are colored. Mammals are generally colored in various shades of gray and brown, while many fishes appear silvery. Only animals that are not exposed to light and live in caves, or as parasites in other animals and plants, or in the earth, are colorless and often blind, with no or underdeveloped eyes.

Mammals are much less colorful than other vertebrates such as fish or birds. This may have to do with the fact that their evolution began when the dinosaurs dominated the planet and the ancestors of the mammals, like the modern shrews, tended to lose brighter colors because they were active at night and lived underground. Mammals are not color-blind but they distinguish colors less well than fish or birds, especially in the shorter wavelengths (blue and green). As daytime activity resumed, so color vision was regained. In contrast, birds, reptiles, and fish are often strikingly colored; these animals possess exceptional powers of sight, even including ultraviolet light, which for us humans is invisible. For that reason, they do not use the sense of smell to know the world around them to the same extent that mammals do.

Dark pigmentation means that animals cannot be so easily detected by predators (camouflage). Many camouflages exploit patterns and shades of color that are adapted to the appearance of the background. Caterpillars and tree-frogs are often grass-green, the polar bear is snow-white, the mouse sandy. A dark coloration on the back and a lighter underside is found in many animals; such countershading tends to obscure the shape of the animal in a top-lit environment. There are also seasonal changes in coloring and color pattern; thus some mammals living in the snow have white fur only in winter, and several bird species are camouflaged while incubating their eggs but become brightly colored again after molting for the next breeding season.

A special kind of camouflage is a pattern that sends confusing signals that disguise the appearance of an animal in order to avoid detection by a predator, such as eyespots on the hind wings of butterflies. Although such cases are not about attraction or deterrence, they are still about cognitive perception, in this case a predator failing to see its prey because evolution has chosen these cryptic patterns or colors. There are astonishing adaptations in all branches of the animal kingdom, whereby animals adopt the form of another (inedible) object such as stones, bark, or dried leaves; this is called *mimesis*.

Many animals are brightly and strikingly colored, and this coloration is often the opposite of camouflage. Rather, it serves to frighten. This kind of communication by warning coloration is called *aposematic* (from Greek: *apo* = "away from," *sema* = "signal"), by which not only the presence of the prey but also its disagreeable taste or ability to defend itself is signaled to potential predators. The best-known examples are bright red, white, and black stripes in snakes and yellow or brown and black striations of the hindbody or abdomen of bees, wasps, and some caterpillars.

Predators associate a particular color pattern with a poisonous or unpalatable prey. It is interesting that these warning colors are often the same or very similar in different species, relieving the predator from the necessity of learning several different patterns by dangerous trial and error, and is thus advantageous both for the sender and for the receiver.

Even more surprising is that nonpoisonous animals frequently show the color patterns of a poisonous species, and are thus also avoided by a predator. This is called *dishonest signaling* or *mimicry*. For example, hoverflies, which are completely harmless, have a yellow-and-black-striped abdomen like wasps, and thereby avoid being caught. The same thing happens for some harmless snakes, whose red-, black-, and white-striped pattern looks confusingly like that of the poisonous coral snakes. It

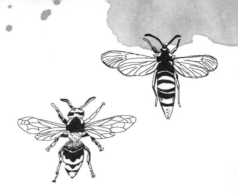

The harmless hoverfly imitates the coloration of the abdomen of the poisonous wasp.

is interesting that also in human communications these color combinations, black and yellow or red and white, are used in warning notices or traffic signs. Blue and white signals, on the other hand, seem to be attractive. This is the color pattern of the "cleaner" fish, who lives in coral reefs and removes the external parasites of other fish, and signals friendliness by his blue and white color combination. Here too there is a form of mimicry, by a fish that look like a cleaner fish but lives from biting chunks out of the skin of its victims.

Communication

Striking colors, as seen especially in insects such as butterflies and also in fish and birds, frequently contribute to social contacts between individuals of the same species. With these cues they recognize appropriate sexual partners as well as rivals. With

animals that live territorially there are regularly fights at the territorial boundaries that ensure fair allocation of space across a suitable area. That is true of birds that breed in colonies, as well as of fish such as the male three-spined stickleback, whose red throat provokes furious attacks from his neighbors. It is not always the males alone who are the aggressors. Males and females of the truly improbably colorful fish who live in coral reefs look alike and defend their territorial boundary together. Fish with different color patterns are completely ignored while a fish of the same species, who will be their strongest competitor for food and other resources, is recognized by color pattern and driven away. That the male and female pair spare each other shows that they recognize each other individually, supposedly by specific behavior patterns. Their offspring are also brightly colored but distinctly patterned, and are also spared by the parents until they develop the adult coloration.

Fish and birds that live in colonies or social groups recognize each other by their patterning, as one can see clearly in aquarium fish, which form ordered shoals. In regions densely populated with multiple fish species, each species must recognize its own in order to breed successfully. Shoaling has the function of avoiding predation since in a group of identical-looking individuals it is much harder for the predator to focus on a single prey fish. The patterns and colors that serve for self-recognition of

an individual species are completely arbitrary but clearly differ from those of closely related species.

Social birds have been particularly well studied. In such species many signalling patterns are known that are triggers for specific instinctive social behaviours. The recognition of sexual partners, of young birds by parents and of parents by the young, depend on such patterns. The juveniles often show distinctive coloration and species-specific markings on their heads, whereby they can be recognised by their parents. In nestlings begging to be fed, the characteristic appearance of the throat during the gaping response stimulates the parents to deliver the food. Social animals present special markings during specific rituals dedicated to greeting, territorial defence and appeasement.

The same colors and patterns that excite territorial fights between male animals look good to females (sexual attraction). They are displayed by the males during sexual courtship, often accompanied by ritualized dance-like movements. It is thus with the three-spined stickleback, whose scarlet chest lures the females to the nest where they then spawn. Some researchers have argued that pairing success does not strictly depend on the attractiveness of bright colors or patterns, but rather that these characteristics primarily display vigor and health. But less complex markings would also serve that purpose, and they need not vary from species to species. Everybody knows the striking

and beautifully colored feathers of birds of paradise, peacocks, ducks, and hummingbirds, which formerly were widely used to decorate hats. These features are dramatically displayed in mating rituals and serve to attract the females. In many cases the ability of the male birds to fly is seriously impaired by their ornaments. The flightless male Argus pheasant, so well-described by Darwin, has greatly elongated wing pinions whose feathers are strikingly ornamented with a row of eyespots. In the mating ritual these pinions are spread out to form a wheel-like fan that attracts the females, who are indifferently ornamented and can fly. In terms of ability to fly, the famous peacock is certainly not better off with its long tail feathers that spread to form the spectacular fan.

Even if other animals, unlike humans, cannot beautify themselves with art, some animals are nevertheless well able to use all sorts of materials to build objects that can also be attractive, such as nests that are carefully crafted and built by males to attract females. The males of the Australian bowerbirds, also mentioned by Darwin, build complex display nests out of upright twigs whose entrances are ornamented with colored objects that they collect and bring to the nest. The female birds find these nests (and their builders) very attractive. Amazingly, the nests are not used for sleeping or bringing up the young, but are built only for showing off.

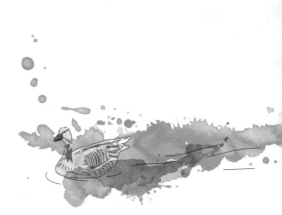

For birds with display plumage, it is the females who recognize conspecific males and select their mates. The females are generally camouflaged to avoid being seen when they are breeding. However, in some beautiful and strikingly colored bird species, the two sexes look the same or very similar, like the kingfisher with shining gentian blue plumage, or the robin redbreast. It may be that there are indeed color differences in the ultraviolet region of the spectrum that are invisible to us. Or perhaps they breed in holes where camouflage is unnecessary. The two sexes are also similarly patterned in many

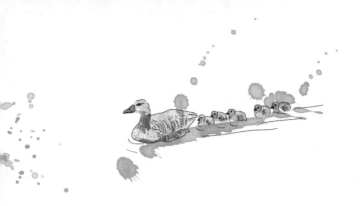

Goose and gander are similarly colored; the children follow the mother, while the father guides and protects the family, which is also held together by sounds and calls.

mammalian species, like cats, tigers, leopards, and zebras. Perhaps in these cases the beauty of both sexes is needed for mutual attraction, or else the color patterns have other functions. It depends very much on the social environment in which these animals live, how they defend themselves, how they find partners, and how they behave. Indeed, not only visual but also auditory and olfactory components may be decisive in mate choice. For humans, attractiveness and beauty of the females play a major role in mate choice, just as do the attributes that make a male handsome and attractive.

In many cultures striking ornamentation of both sexes also has great importance in ritual activities. The artificial attributes that females use to enhance their beauty generally emphasize health and youth, while for males it is more strength and status.

In some species, especially birds, sound signals and songs fulfill functions in communication that are similar to visual stimuli. Calls signaling particular states (situations or moods) hold groups together and stimulate specific reactions in the recipients. Such calls are not conscious in the sense that the sender does not intend to induce a particular response in his companions. They cannot be suppressed, and also happen when no recipient is there to hear. Individuals of the same species can recognize each other personally by the sound of the calls. These calls are innate, and through experience they can be modified, within limits. The situation is different with the recitals of songbirds, which have a specialized larynx with which they can produce a variety of beautiful notes and sounds. These songs are often artfully constructed from a variety of different phrases and repeats. They are specific to each species, are mostly sung by the males (but heard and understood by the females), and may be innate or learned during childhood. Amazingly, the nestling can distinguish the song of its father from the many other songs that it hears, and imitates it much later when it itself begins to breed. Birdsongs repel male rivals and serve to define and defend territorial

boundaries in the same way as color patterns in birds and fish. The conspecific females, in contrast, are attracted by the best performers. In the case of birdsong there is even evidence for traditions in which especially favored variations are transferred by imitation to subsequent generations.

Pattern Recognition

As explained above, color patterns have important
functions in social communication. To fulfill these
functions, color patterns must be accurately rec-
ognized and not confused with other signals. The
same is true for bird songs. One might compare

this kind of communication by stimuli, recognized either through sight or sound, that induce a specific reaction with a language whose words must be understood in order to function. Many of these stimuli are innate, for instance the recognition of an animal's own young. The broods of chickens, ducks, and geese abandon the nest after hatching and are led around by the parents. That recognition must therefore be achieved immediately; there is no time for learning. Spontaneous vocalizations also play an important role in this. Nesting birds by and large do not recognize their own young and feed everything in the nest so long as it opens its mouth wide; the cuckoo is a famous exploiter of this behavior. The recognition of parents by the young occurs in some bird species through a remarkable mechanism called imprinting. In this process the image of the animal that the new hatchling sees briefly on the first day is stamped on its memory in such a way that it never forgets, and thenceforth recognizes this and no other animal as its parent. If this brief window of time is missed, this knowledge can no longer be acquired. As Konrad Lorenz showed, the imprinting process is clearly different from normal learning, which is not coupled to a specific developmental stage and whose content can be forgotten. Obviously, under normal conditions imprinting works well and no mistakes arise, because the freshly hatched chick sees its parent first of all and then "knows" what species it belongs

to. Imprinting also occurs in fish, whereby they recognize their own species in the shoal that they have grown up with, but probably not in mammals. There are many examples of learned recognition of conspecifics in other social situations, for example among siblings, in herds, or flocks of birds.

Recognition of dangerous or poisonous animals by their appearance can be innate, or learned by the unpleasant experience of eating some disagreeable prey. Young animals may be alerted to dangerous animals such as snakes by cries of alarm from their parents. This is automatic learning by association, and the alarm signals occur spontaneously and cannot be suppressed.

How is it, then, among animals other than humans, regarding the capacity to recognize beauty? Do they have an aesthetic sense? Doubtless many aesthetic characteristics induce pleasure, are "aesthetically pleasing"; but that applies basically only to the females, who can be greatly aroused by the display plumage or song of the males. The very same aesthetic signals may cause a male to run away, or provoke him to a fight. In addition, the attractiveness of any animal is completely limited to species-specific signals; other, to us equally or indeed more beautiful, features are completely neutral unless they clearly resemble the species-specific ones. Such patterns are judged attractive only by conspecifics, and not at all by animals of other species. Mix-ups may happen between individuals of closely related

species, especially when no conspecific animal is available. Every species has its own perceptive range and its own characteristic behavior in response to visual and acoustic signals. It is important always to bear in mind that we have a tendency to anthropomorphize animals, attributing our own perceptive powers to them. A general aesthetic sensibility is indeed unique to humankind; we find beauty in objects that have no function in a social context, including natural objects such as landscapes and sunsets. To humans, the most widely different patterns can be beautiful, even those that excite dread in other animals, such as warning patterns. Humans adapt and extend their own inherited standards of beauty with artificial attributes, creating fashions, handed down by different cultures as traditions to later generations.

II The Development of Colors and Patterns

There is grandeur in this view of life, with its several powers, having been originally breathed into a few forms or into one; and that . . . from so simple a beginning end-less forms most beautiful and most wonderful have been, and are being, evolved.

Charles Darwin, *On the Origin of Species*, 1859

Colors

It is remarkable how similar the physical and chemical methods are by which animals and humans create colors, textures, and iridescence to adorn their external surfaces. Colors are generated in two rather different ways, either through pigments, that

is, through chemical compounds that absorb part of the light spectrum, or through very tiny physical structures that interfere with visible light. Such nanostructures may themselves be colorless but alter the appearance of the color of the pigments. They are also responsible for the shine and shimmer of iridescence.

Animal pigments are organic chemicals that absorb light of certain wavelengths so that only the remainder of the spectrum reaches the observer. Melanins are dark pigments very widely distributed in the animal kingdom that absorb light across the whole visible spectrum, even appearing black in extreme cases. They are responsible for the dark coloring of animals and are the only pigments that mammals can produce. They are the pigments that make human hair brown or black and can also adopt lighter colors, giving reddish or yellow tones. Melanins are polymers based on chemical modifications of the aromatic amino acid tyrosine. Melanins are synthesized in pigment cells (melanocytes) and stored in vesicles called melanosomes. There are two kinds of melanin: the nearly black eumelanin and the somewhat reddish pheomelanin. The quantities and ratios of these two compounds can vary, and thus determine the perceived final color. The synthesis, storage, and transport of melanins in and between cells is complicated and involves many genes. Color variations that have been bred and selected in many domestic animals and pets are

due to mutations in these genes. Most humans have black hair and more or less dark skin generated by the mixing of eumelanin and pheomelanin. Pure red hair occurs when only pheomelanin is made; the same gene mutation is responsible for the red color in chestnut horses and in Irish setters. When only the dark eumelanin is made, black, so-called melanistic variations appear, for example the "black panther" variants of leopards, or black horses. In contrast, the light skin and hair color of Northern Europeans derives from a reduction in melanin production caused by reduced enzymatic activity, while the lighter skin color of dark-haired Europeans is due to reduced storage of melanin in the melanosomes.

If pigment cells produce no melanins because of a gene mutation, the result is albinism. Albinos also have a problem with vision because the layer of melanocytes in the retina of the eye is colorless. Eye color is determined by the color of the retina and the iris. The retina, at the back of the eye, contains the light-sensitive nerve cells supported by a layer of black pigment cells that protect the retina from scattered light. The iris, which is also pigmented, functions like a blind, restricting light entering the eye through the pupil and adjusting the intensity of light falling on the retina by widening or narrowing the pupil. When the iris contains little or no pigment, the black retina seen through the vitreous humor of the eye looks blue. Darker pigment in the

Tiny air-filled pockets in alveolar cells over a dark pigment layer make the feather look blue.

iris cells makes green or brown coloring. The eye color of children can change as they grow older, just as cats' eyes are blue at first but become darker after a few weeks. It is interesting that the color of eyes, skin, and hair are all regulated differently.

Birds also mainly produce melanins in various dark tones (blacks, browns, and reds) but their red and yellow coloration derives in many cases from their diet in the form of plant pigments, mostly carotenoids. Flamingos are not pink if carotenoids, derived from green algae and small crustaceans, are missing from the diet! Nevertheless, birds are often brightly colored, and they achieve this through special structures in the feathers that can create strikingly different colors. Air-filled spaces cause structures to appear white because they scatter light of all wavelengths, while on top of a melanin layer they generate a blue color. Blues and greens are also generated by structures reflecting light at certain

angles, covering melanin-containing cell layers. Intracellular nanostructures of stacks of minute disk-like plates cause interference of incident light and generate iridescence, or blue when layered over black pigment. An additional yellow pigment layer generates green.

In insects, reptiles, and fish, yellow and red colorations derive from pigments that absorb blue and green light, chemicals mostly of the class of pteridines, first isolated from butterfly wings (Greek *pteros* = "wing"). White spots found in some butterflies are due to a related chemical substance, leukopterin. Additionally, some colored fat-soluble chemicals such as carotenes or luteins derived from food plants are also used in coloration. Blue colors are almost exclusively generated by nanostructures in combination with melanin, not from the kinds of blue pigment that we know from plants. Thus animals can produce far fewer pigments themselves than plants can. Fish and reptiles generally make more different colors than birds and mammals; combinations of pigments and nanostructures lead to a very rich color palette.

An interesting extension to the color spectrum found in some mammals and birds is achieved by increasing blood flow in naked areas of skin causing reddening, as for example in the lips of humans and the cock's comb. The red blood pigment, hemoglobin, essential for oxygen transport, is so to speak repurposed for the coloration of striking parts of

the skin. A blue coloration, which is very uncommon in mammals but found for example in the face of mandrills, is caused by light interference generated in the skin by ordered arrays of collagen fibers over a layer of melanin.

Skin

For our discussion of animal coloration, it is important to consider the design of the external surfaces of animals, what the integument is actually made of and how it is put together, and how the skin itself is structured and protected.

Animals are built according to very different blueprints that have emerged in the course of evolution. Two great groups of animals, the Ecdysozoa (*ecdysis* refers to shedding the integument during body growth or metamorphosis), to which the arthropods belong, and another great group, the chordates, to which the vertebrates belong, separated from each other very early in evolution. Their body plans are correspondingly very distinct (see the figure on pages 10–11).

The arthropods, the jointed-limbed animals, including centipedes, insects, spiders, and crabs, have an exoskeleton that encases the body in a carapace. The carapace is built out of a cuticle (*cutis* = "skin") that contains chitin, a molecule structurally related to plant starches and cellulose. Chitin makes fibers that are cross-linked by a number of different proteins into very strong and elastic structures that give the body its shape and protect it against the outside world. The strength of the chitinous cuticle prevents it from growing at the same rate as the body; as a result, these animals have to hatch from their cuticle after each growth stage (ecdysis).

The thick and tough cuticle, synthesized by skin cells, provides excellent protection against wounds, water loss, and infection. Chitin, the building material of the cuticle, allows for the formation of an extraordinary variety of structures such as ridges, scales, toothlets, spikes, and hairs, as can be seen in insects, spiders, centipedes, and crustaceans.

Arthropods have an exoskeleton made of chitin and grow by ecdysis, while the strong bony skeleton and flexible skin of vertebrates allow continuous growth up to enormous sizes.

The skin cells also produce pigments that are deposited in the cuticle. The coloration of an insect is thus due to the color of its exoskeleton. Thin layers of chitin in the cuticle overlay pigmented layers and generate different color tones. Color patterns often follow defined anatomical structures like wing veins. The texture of the surface can also lead to different color effects, such as the tiny differently colored scales, each arising from a single cell, that form the mosaic-like color patterns and velvety surface of butterfly wings. The wings are in fact large, flat folds of skin with an upper and lower surface; the upper surfaces are often wonderfully ornamented, while the undersurfaces, which are visible only when the wings are folded, are frequently inconspicuous and camouflaged. In

beetles the carapace of the middle body segment, the thorax, including the front pair of covering wings or elytra, is often brightly colored, while the hind wings, which beetles actually use for flying, are colorless. Bees and wasps have colorless wings but display warning coloration on the hind body, the abdomen. Striking coloring is seen in the compound eyes of many insects, built up from many individual simple eyes. Fireflies and glow-worms emit pulses of bright light from the hind segments of their abdomen, generated by the enzymatic oxidation of a complex organic molecule.

In vertebrates, that is, fish, amphibians, reptiles, birds, and mammals, the situation is completely different. The vertebrate body is supported by an internal skeleton of bone and cartilage, while the skin is soft and flexible and can grow as the body grows. Physical protection is provided by specializations of the skin such as scales, feathers, and hairs, which are not rigidly connected to each other like in the arthropod cuticle, but separated from one another in the skin through stretchable, flexible spaces. Vertebrates generally grow continuously. Although some water-dwelling species have juvenile stages that are clearly distinct from adults, the steps in the transformation from juvenile to adult are generally relatively small.

In contrast to the insects, the skin of vertebrates is flexible and grows with the body. An epidermis many cells thick covers the connective tissue of

In insects, the pigments are made in the skin cells and deposited in the chitin carapace.

the dermis, separated from it by a basement membrane. The epidermal cells produce structurally very robust proteins called keratins that build more or less strongly cross-linked fibers that can assume various textures. Keratins can be very hard and form compact structures, for example horn material, out of which nails, claws, horns, and hoofs are made, but also long, thin, and soft structures like hair and feathers. Inorganic compounds may also be included in horn material. Epidermal cells are continuously renewed, as new cells generated by stem cells at the basement membrane replace the older cells which eventually die, forming a nonliving layer that provides physical protection of the living epidermal cells from injury and water loss, before eventually being sloughed off as flakes. In the dermis, strong and elastic fibers of collagen provide

The skin of vertebrates is several cell layers thick and colored by specialized pigment cells.

structural support for the skin. Collagens are proteins consisting of three intertwined chains of high tensile strength. Through extensive cross-linking, they build up an extracellular matrix that supports the physical form of an animal.

Since the skin itself is soft and pliable, it is protected in many vertebrates by specialized structures. This role is played in fish by the scales, small, thin bony disks covered in a minimal epidermis that develop in thickened areas of the dermis called placodes. In snakes and lizards, and on the feet and legs of some birds, thin horny scales develop in the epidermis. These are robust structures made from dead epidermal cells that stay loosely attached to the skin through thin extensions of the epidermis. These scales do not grow with the skin, so snakes and lizards have to molt several times during their

lives, discarding the external dead layer. The skin cells underneath have already prepared new, larger scales. This situation is similar to that in growing insects who periodically molt and replace their cuticles. Amphibians such as frogs and newts, which live in moist environments, have relatively thin skin that is covered in layers of slime to limit water loss. The scales of snakes and fishes are generally transparent; the colors of fishes, amphibians, and reptiles come from pigment cells arranged in layers in the dermis.

In mammals and birds, who have to maintain constant warm body temperature, the skin develops hair and feathers, organs specialized for thermal insulation. These structures may serve many other functions. Beyond regulating body temperature, they also protect the skin against bugs, lice, flies, and ticks, help to deflect water, and are often beautifully colored.

Hair and feathers are both derived from the epidermis. Like the scales of reptiles they are made of the horn protein, keratin. Just like the scales, hair and feathers develop in placodes. These thickenings of the epidermis invaginate and develop at the base a papilla or cluster of hair cells that divide and produce keratin. The developing hair consists of keratin from dead hair cells and grows out as a thin, hollow tube. Modifications in the structure and cross-linking of hair keratins result in different hair textures, coarse or fine, frizzy or smooth. Melanin pigment is produced in melanocytes that surround the hair cells and is

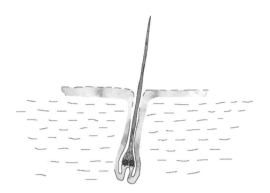

Melanin pigmented hairs grow from below in an
epidermal papilla firmly anchored in the dermis

deposited in the growing hair. Blonde, gray, or white
hair contains little or no melanin. This is replaced by
small air pockets that scatter light and give the hair
its light appearance. White or light gray horses are
often dark colored in their youth, and develop light
colored hair only later through premature loss of the
pigment cells. Many humans go through the same
process later in life. In some animals, parts of each
hair are differently colored, for example light at the
tip and dark at the base.

Feathers are branched keratinous structures
based on a main shaft and side branches. Like
hairs, they form in the epidermis. Feathers vary tre-
mendously in appearance according to their func-
tion and position on the body, and are surely one
of the most astonishing structures in nature. The

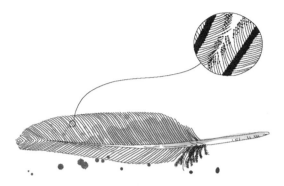

The vanes of contour feathers are built up of parallel filaments linked to each other by tiny hooks called barbules.

outside feathers, the so-called contour feathers, provide the bird with its external covering, while the downy feathers underneath serve as insulation. The contour feathers have a long shaft with feather branches on both sides. These branches are connected by hook-like structures to form the elastic, stretchable "vanes" of the typical feather. The vanes of contour feathers, for example in the wing, are usually of various widths, with the narrow vane on the exposed surface and the broader vane on the inner side, under the next feather. When the wings are closed only the narrower outer vanes are visible. In down feathers, the side branches are not connected, so these feathers have no vanes but rather small thickets of fine branches.

The filaments of down feathers and specialized hair-feathers or "filoplumes" are not interlinked by barbules.

Feathers are developed in feather pouches, small rounded depressions in the epidermis, with both nerves and a blood supply. As in hair formation, inside is a small papilla whose cells make keratin, of which the shaft and side-branches of the developing feather are composed. The feather grows from the base and is extended bit by bit to the outside. The blood and nerve supply is maintained until the feather is complete; at this point the feather becomes a lifeless appendage anchored in the skin by the feather sheath in which it formed. The extraordinary variety of shapes and forms in the ornamental feathers of birds of paradise, peacocks, ostriches, and hummingbirds arises from variation in the construction of the feather vanes.

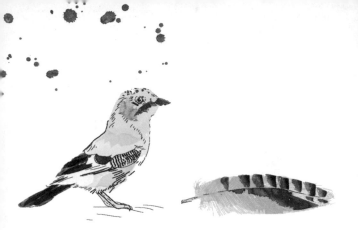

Only the visible part of the contour feathers displays the beautiful blue stripes on the jay's wing.

Like hair, feathers are also colored, as pigments such as the dark melanins or red carotenoids are delivered from the papilla to the growing feather. Minute air-filled spaces or nanostructures distributed over the dark pigmented layer can alter the apparent color through light scattering. On the wings, the feathers lie partially overlapping on one another like roof tiles, and amazingly only the visible part of each feather is ornamented. When the wings are folded the visible parts of the feathers together form a pattern that almost looks painted on. It is really puzzling how these wonderful integrated patterns arise, because each feather develops separately from its neighbors. Sometimes, for

example in ducks, the tips of the feathers are hardly colored after the molt, and the beautiful colors appear only after these regions have worn off, because the melanin makes the colored parts of the feathers more durable.

Neither hairs nor feathers last a lifetime; rather, they are either continuously or intermittently (as in molting) lost and replaced. In hairy and feathered parts of the body the color is all in these structures. Apart from hairless parts of the body such as the nose or the soles of the feet the skin is generally not pigmented. One exception is the polar bear, who has black skin under the white fur. Another is humans.

Making Patterns

But what is responsible for the formation of the beautiful color patterns of animals? How are bodies ornamented? How does the spatial distribution of different colors in various regions of the body develop? Color patterns of astounding complexity

seem to form as if by magic from undifferentiated tissue. Essentially, the problem is to explain how shape arises from uniformity, and thus how patterns emerge from initially homogeneous cellular assemblies.

In animals, embryonic development in the egg is the earliest kind of pattern formation, and how that happens has fascinated biologists for hundreds of years. The egg cell is an apparently homogeneous blob of cytoplasm that looks not in the least like the animal that will emerge from it. What comes out is an individual whose every organ and differentiated tissue is just where it should be. Already by the beginning of the twentieth century researchers recognized that shapes and forms become increasingly complex during embryonic development, but the material basis for developmental patterning was totally puzzling. Experiments to identify pattern-forming factors were unsuccessful, providing room for plausible, albeit untested, theoretical models of development. According to one such proposal a mosaic of preexisting materials anticipated subsequent patterning and, by determining the spatial distribution of bodily components, enabled the final development of the mature form. "Determinants" were postulated, localized in specific places in the egg that defined the development of organs and other structures. However, this notion left it quite unclear where the determinants come from or how specific structures might develop

In the egg cell of a fly, the morphogen is distributed in a gradient. Different local concentrations cause different developmental outcomes.

from them. In 1969 the theoretical biologist Lewis Wolpert proposed the concept of "positional information," by which gradual changes in concentration of hypothetical substances (morphogens) across a biological "field" could define positions as spatial coordinates. High concentrations would determine, for example, where the front end of the animal (the head region), would be laid down, while lower concentrations would determine the position for development of the hind regions. Regions of different concentrations of a morphogen would have different developmental outcomes; by this kind of argument, it was possible to explain not only increasing complexity, for example during

embryonic development, but also the development of color patterns.

At that time, however, the molecular basis for these concepts was not known; as a result, such biological gradient models were unpopular: "An outsider to embryology has the impression that in recent years gradients have become a dirty word. This is partly because of the failure to isolate unambiguously the molecules involved whose concentration is presumed to constitute the gradient" (Francis Crick, 1970). Life was easier for the theoreticians, who simply operated as if morphogens were molecules with specific pattern-forming properties, and that by means of defined positive and negative interactions they could form astonishingly regular and stable patterns. A pioneer in this field was the mathematician Alan Turing, one of the forerunners of the modern world of computers and informatics. In 1951, he developed a simple model of a morphogen spreading by diffusion whose local concentration was regulated by a likewise diffusible inhibitor. Under certain conditions, an equilibrium can develop in a two-dimensional field leading to pattern-like distributions of stripes or spots. This Turing model was still too simple to explain realistic biological situations. The mathematical theory of biological pattern formation developed by Alfred Gierer and Hans Meinhardt in 1972 is decisively better. This too is built from the interaction of two pattern-forming substances, an "activator"

(morphogen) and an "inhibitor." The activator positively reinforces its own activity (autocatalysis) but has only a short range, while the inhibitor spreads further and inhibits the activator (lateral inhibition). This model makes no prior claims about the nature of the molecules themselves, or about how they might spread; it could be by simple diffusion, but alternatively perhaps by transport along cellular extensions. Astonishingly many different biological patterns could be simulated by computer simply through varying the parameters of the interaction between activator and inhibitor. Despite this, the problem with all these models is that, even now, the molecules functioning as morphogens/activators and inhibitors have rarely been identified. Even so, such mathematical models of biological pattern formation are still attractive because they are very flexible and can simulate anything, even in cases where we really know nothing, for example, how the tiger's stripes or the dots on a bird's wing arise.

In Gierer and Meinhardt's models, stable gradients and patterns emerge through self-organization from an initially almost uniform distribution. Meinhardt showed that these models could provide an elegant explanation for the amazing geometrical patterns on the shells of cone snails; the patterns themselves probably have no function; they form spontaneously because of the way the shell grows at the front margin. Similarly, the beautiful mother of pearl, which has no aesthetic function, forms

The elegant geometrical patterns on some snail shells are probably caused by simple rules of interacting chemical gradients, as predicted by Meinhardt's theory.

spontaneously unseen inside the oyster (mussel) shell. However, pure self-organization happens in very few biological systems. Most systems already begin with clear inequalities in the distribution of elements; patterns generally build on preexisting so called pre-patterns. This was clarified by systematic genetic analysis in the case of the fruit fly, *Drosophila*, which led to the discovery of genes that encode morphogens.

From this study on fruit flies it was established that the egg obtains from the mother fly key pre-patterns in the form of localized signals from which morphogen gradients spread into the inside of the egg. These signals are anchored to the front and hind poles and to the ventral side. The morphogen "Bicoid," essential for the development of the head, was discovered in my laboratory in 1988. The

In cellular tissues, locally produced morphogen spreads through the spaces between the cells.

localized signal that serves as the source of the morphogen gradient is the messenger RNA that codes for the Bicoid protein, and is anchored to the anterior pole of the egg during its development in the mother fly. There the Bicoid protein is synthesized, then, in the absence of cell boundaries in the fly egg, diffuses toward the posterior region. Regions of high Bicoid concentration develop into the structures of the head, of medium concentration to structures of the thorax, and of low concentration to structures of the abdomen of the fly embryo. The Bicoid protein is a transcription factor and controls the activity of downstream genes. Bicoid was the first morphogen for which it was shown that indeed different concentrations of a substance induce different structures.

The fly egg has three additional anterior-posterior gradients and one that directs organogenesis in the

back-to-belly (dorsal-ventral) axis. It is interesting that neither autocatalysis nor lateral inhibition contributes to the establishment of gradients in the fly egg. The molecular identity of the morphogen in each of these gradients is different, as is the mechanism for its spread and its translation into spatial structures. There is thus no specific molecular type for morphogens, nor any unifying mechanism of action. In cellular tissues such as the imaginal discs producing the skin of the adult insect, and in the epidermis of internal organs, protein gradients spread from their sources through the spaces between cells, and their local concentrations at certain distances from the source stimulate specific responses from the cells. In these cellular systems the morphogens are proteins that bind to receptors exposed on cell membranes that transmit signals into the cytoplasm. This is how the color patterns on insect wings develop. These patterns are guided by existing structures such as wing veins or segment boundaries, which function as pre-patterns and provide the spatial cues for the local synthesis of pigments or other structures. These are examples of how patterns can be produced, but it is clear that there are many other possibilities. In particular, the origin of color patterns in vertebrates is far from completely understood. Here the patterns are produced by pigment cells that migrate long distances into the skin and assemble like a mosaic into the most extraordinary ornamentation for which the vertebrate body provides no obvious pre-patterns.

Pigment Cells

There are thus two ways an animal can acquire color patterns: either the skin itself is pigmented, or special colored cells, pigment cells, distribute themselves in the skin. As we have seen, the first case is characteristic of the Arthropoda, for example the

insects, which produce pigment in skin cells to be deposited in the cuticle. In the second case, in the vertebrates, the pigment cells are distributed in the dermis, over the muscle layer. In cold-blooded vertebrates, the fish, amphibians, and reptiles, pigment cells occur in a variety of colors and shapes, while birds and mammals possess pigment cells of only one type, the dark-colored melanocytes, that transfer their pigment to skin, hair, and feathers. In fish, amphibians, and reptiles, differently colored pigment cells, melanophores, xanthophores, or erythrophores and iridophores, are distributed in layers, with the melanophores underneath, above them iridophores that reflect or scatter light, in turn overlain by yellow- or orange-colored xanthophores or red erythrophores. Blue light is absorbed by the orange or red layer on top, and the melanophores underneath can absorb light of all colors. Reflection of light rays through the iridophores in between creates silvery, blue, or green tones. That is an extraordinarily refined arrangement; many different colors can be produced through the superimposition of the pigments cells in different states. Patterns arise from variations of the layers, where the shapes, arrangements and colors of the cells can vary. In principle, these color patterns are thus based on a multilayered mosaic of individual cells in which the upper cell layers let the layers underneath shine through.

The three pigment cell types, yellow, silver, and black, are arranged in layers one above the other.

Yellow xanthophores and black melanophores are multibranched cells that make contact with one another through numerous extensions, while the iridophores are more densely packed and can form tight groups that completely reflect the light and appear white or silvery. In the pigment cells, the colors are enclosed in specialized vesicles; in iridophores, vesicles that almost fill the entire cell contain tiny flat crystalline plates. The color-containing vesicles in melanophores can be moved back and forth inside the cells, thus changing the brightness and depth of color of the cells. This process is called color change: when the melanosomes are concentrated in the middle of the cell, the cell group looks light, and when they spread out to the cell periphery it looks dark. This is how chameleons change their color, as

well as how many frogs and fishes can change color according to physical or mental state, or to adapt to the color of the physical background. In the last case the background is apprehended initially through the eyes and then imitated, a baffling process since it is not simply a decision whether to be dark or light, but also allows an adaptation to the patterning or graininess of the background coloration. Blinded fish are always dark; sick or sleeping fish are light.

Color changes also occur in some large mollusks such as octopuses and cuttlefish. In these animals, the pigment cells are small lens-shaped bags filled with pigment. Muscles are attached to them in a radial pattern, such that when relaxed, the pigment is concentrated in a tiny dot, but contraction stretches the cell and its pigment over a larger area, causing a darkening of the skin. These color changes, which serve both for camouflage and in fright responses, are controlled by nerve impulses and can happen like lightening.

Male fish frequently display bright yellow or red during courtship, showing that xanthophores and erythrophores can also undergo color changes. The color transformation can be extremely fast, but little is known about the mechanism. Color transformations in this sense do not happen in birds and mammals because in these animals the pigments are in dead structures, hair or feathers. But they can make their hair or plumage look very different according to mood by spreading, wrinkling, or ruffling.

Color change happens through redistribution of the black
vesicles in the melanophores.

The pigment cells of vertebrates do not develop
in the skin, and unlike in insects they are not orig-
inally part of the skin but migrate into the skin
during the course of development. Where do they
come from? Pigment cells of vertebrates are prod-
ucts of the neural crest, a developmental innovation
that arose about 500 million years ago during the
evolution of the chordates. The neural crest consists
of strings of cells that extend along the back of the
embryo on both sides of the neural tube, the devel-
oping nerve cord. Neural crest cells have two prop-
erties that distinguish them from their neighbors:

1. They are multipotent, that is, they can differentiate into many different cell types.

2. They migrate long distances away from where they arise and provide specialized cells to a variety of organs.

The contributions of neural crest cells to the vertebrate body were researched above all by the French scientist Nicole Le Douarin. She noticed that the cells of chickens and quails differ in the appearance of the nucleus in a way that can be identified microscopically. She was able to transplant neural crest cells between embryos of the two species to create "chimeras." The difference in nuclear structure enabled her to find out which structures develop from the neural crest. The largest contribution was the delivery of cells to the structures of the head, bones of the skull and the jaws, the teeth, horns, beaks, and gills. These evolutionary developments provided our ancestors, developing from the simple, headless "protochordates," with new ways to take up food and capture prey. The peripheral nervous system, linking bodily organs and skin to the central nervous system of brain and spinal cord, also develops out of cells from the neural crest. Finally, all the pigment cells of the skin originate in the neural crest, which thus made a decisive contribution to the evolution of vertebrates as large and brightly colored animals.

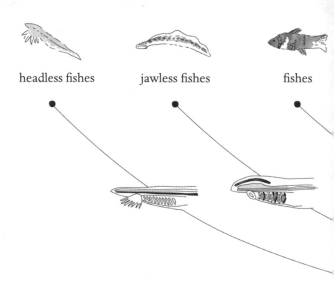

headless fishes jawless fishes fishes

Evolution of vertebrates. The bodies of vertebrates are all built on the common principle of a flexible rod-like structure, the "notochord," already developed in their precursors, the protochordates, during the Cambrian era. During this period, around 540–480 million years ago, nearly all the major groups of animals arose. The original "chordate" animals were tiny, spindle-shaped, and headless creatures that fed by filtering plankton through a gill-like sieve. The development of the head from these simple forms was decisive in the evolution of large vertebrates. Bony plates derived from the skin created a skull to protect the brain, enabling it to grow much larger. Later came the jaws and teeth, whose

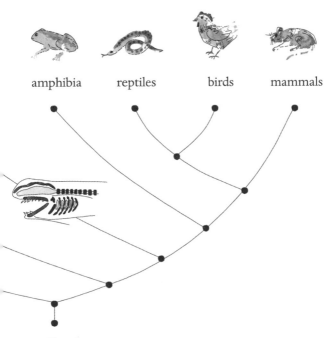

amphibia reptiles birds mammals

Chordates

specialization allowed the exploitation of an enormous
variety of food sources. All these head structures evolved
from the neural crest. The flexible vertebral column, evolv-
ing from the notochord and associated tissue, stiffened the
long axis of the body and protected the spinal cord, a part of
the central nervous system. Two pairs of limbs arose from
placode-like structures that, in fishes, are still simple fins, but
in the other vertebrate classes turn into jointed arms, legs,
or wings. As they moved onto land, a new specialization de-
veloped, the amnion. This is an embryonic membrane that
enfolds the embryo and protects it from dessiccation, mak-
ing egg development possible in land animals.

During early development in mammals and birds, the precursors of pigment cells migrate underneath the skin from their source in the neural crest on the dorsal side of the body toward the ventral side. They supply the feather roots and hair follicles with pigment cells that deposit their dark or red pigment between the keratins of the growing structures. In domestic animals, such as horses, cows, pigs, and cats, genetically determined color variations may occur in which pigment cell migration either fails entirely or is not completed. These animals are either completely devoid of melanocytes, and therefore completely white, or show color patterns such as white blazes or piebald colors, often on peripheral parts of the body such as feet, head, or tip of the tail. Several genes have been identified whose mutation leads to such local loss of color owing to incomplete migration of neural crest cells. Such variations are also known in humans.

The genetic basis of coloration in mammals has mostly been researched in laboratory mice. In mice, we know of about a hundred genes that influence coat, skin, and eye color. Many of these have complex functions that also have an impact on other important processes, making their analysis difficult. Migration of neural crest cells are hard to follow in classical laboratory animals such as mice or chickens because the embryo develops either in the mother's uterus or in the egg and is therefore inaccessible to direct observation by microscope. As

a result, not much was known until recently about how pigment cells coming from the neural crest reach the skin and contribute to the coloration and patterning that adorn so many animals.

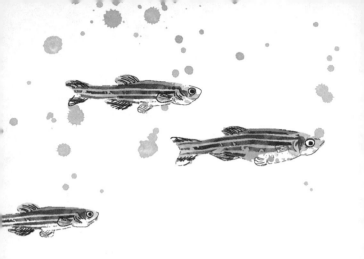

Zebrafish

Over the last thirty years the zebrafish has proved to be an ideal experimental animal for many areas of biological and medical research. It is a small shoal fish from warm Indian rivers that has long been popular in aquariums. Zebrafish lay abundant, rather

large eggs that are initially transparent and therefore make it possible to follow in the microscope the earliest developmental stages in the living embryo right up to the swimming larva. This marks the zebrafish out as especially suitable for experimental studies designed to illuminate the principles of vertebrate development, in contrast to the chicken or the mouse. Genetic manipulation is also comparatively easy, and mutations causing loss or alteration of the function of a gene help to identify molecules that are important for specific developmental events.

For our present inquiry, we are concerned with the prominent and elegant color pattern of the zebrafish, consisting of parallel blue-gold stripes along the body. Both sexes develop the stripes, which are probably important for kin recognition during shoaling. The color pattern of the zebrafish is assembled in the dermis from the classical arrangement of the three pigment cell types; in the lowest layer the melanophores, in the top layer the xanthophores, and with iridophores in between. The melanophores are present only in the dark blue stripes. Xanthophores and iridophores are present in both dark and light stripes, but in different shapes. Over the melanophores of the dark stripes the iridophores form a loose network that is responsible for the iridescent blue colour. Above these iridophores are star-shaped xanthophores with long processes. In the golden light stripes, iridophores are densely packed under intensely colored xanthophores with

The precise superposition of the pigment cell types in different shapes creates the gold and blue of the stripes.

short processes. The sharp contrast and coloration of the stripes is due to this very precise layering of the different pigment cell types. The iridescent silvery color of the fish is further enhanced by the presence of numerous iridophores that cover the visible parts of the scales. The tail and anal fin are also striped in zebrafish, and the pectoral fins are colorless, while on the other fins and on the scales the pigment cells are mixed. The near transparent larvae, which hatch from the egg a few days after fertilization, are less generously colored. This earliest pigment pattern consists of narrow rows of pigment cells along the back, lateral line, and ventral side. On the dorsal side the larvae are yellowish.

In zebrafish it is possible to observe the migration of cells in the living animal using time-lapse

photography. Specific cells can be marked with dyes to make them easily visible in the microscope. The neural crest develops on the dorsal side of the embryo on both sides of the tissue that will form the neural tube in the midline. By the end of the first day of development, the neural crest cells begin their migration along two routes: an outer route directly under the skin, and an inner route along the inner side of the segmental muscle-forming cell bundles known as the somites and along the central nervous system and notochord. The color pattern of the larva is developed directly from these early immigrant cells. Some melanophores and the xan-thophores migrate by the outer route toward the ventral side. The xanthophores, which maintain contact with each other through long processes, loosely cover the somites in each segment. Irido-phores and other melanophores, as well as cells of the peripheral nervous system, migrate by the inner route. These cells arise during the first day of devel-opment and follow the growing nerves that will serve the musculature.

The seamless colonization of the skin with pig-ment cells happens only as the young fish goes through metamorphosis at the age of about three weeks. Most of the fins (the pectoral fins are already present in the larva), as well as the scales, develop at this time. In a fish about two months old the stripe pattern is complete.

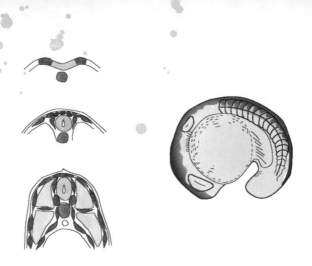

Migration of neural crest cells. To follow the migration of neural crest cells during development we used fluorescent proteins, for example the "green fluorescent protein," GFP, and its red fluorescing variant, RFP, that were discovered in deep-sea jellyfish. Using gene modification techniques, we linked the genes encoding GFP or RFP to a control region of a zebrafish cell-type-specific gene and stably integrated them into the fish genome. "Cell-type-specific" means that the gene control region activates the gene only in a specific cell type. In such transgenic fish this cell type produces the RFP or GFP and therefore fluoresces red or green. In this way, we generated fish that produce RFP under the control of a gene that is active only in neural crest cells. This made it possible to follow the migration of neural crest cells during fish development. Neural crest cells following the inner route migrate in segmental groups, progressing from anterior to posterior, toward the ventral side. The migrating cells use their extensions to feel the way.

During metamorphosis the number of xantho-phores increases by replication of the preexisting larval cells. In contrast, the melanophores and iri-dophores of the larva disappear; these cell types are replaced by new cells that appear at the beginning of the third week. By this time, the neural crest is no longer present; where do these new cells come from? This was a puzzle until a couple of years ago, when, using new microscope techniques, we could show that they come from stem cells.

Stem cells are undifferentiated embryonic cells that are found in many tissues and organs of the body. They give rise to new differentiated cells that contribute to the growth of the organ. Stem cells also make an important contribution in replacing cells that die after fulfilling their function, as skin or intestinal cells, or during wound healing. During the migration of neural crest cells along the motor nerves that innervate each segment some large cells stay behind at the place where each nerve emerges from the spinal cord. These develop into the nodes of the peripheral nervous system from which nerves leave to connect to the skin. The stem cells that will later develop into the pigment cells of the mature fish are also present in these nerve nodes. At the beginning of metamorphosis, these stem cells begin to produce the progenitors of pigment cells of the mature fish. They migrate into each segment, their route guided by the nerves, past the segmen-tal groups of muscle cells and into the skin. They

Pigment cells arise from stem cells and migrate into the skin by following the nerves along three different paths.

migrate along three routes: dorsal, that is, upward toward the back; ventral, that is, toward the belly; and sideways, through the horizontal myoseptum, a structure that separates dorsal and ventral muscle groups.

Now the stripes begin to appear; pigment cells emerge in the skin at the beginning of metamorphosis. The first iridophores reach the skin at the horizontal myoseptum and form clusters over each segmental muscle group. These iridophores are densely packed and increase in number by cell

division to the point where the cell clusters from each segment fuse and the first light stripe with a width of about ten cells is complete.

Subsequently, iridophores from the upper and lower edges of the lateral groups change their structure from the compact form into a loose migratory form and spread both upward and downward in the skin with frequent cell divisions. The melanophores of the dark stripes emerge from inside in these marginal zones, but they do not divide in the skin; rather, their progenitors have multiplied earlier during their migration along the nerves. As soon as the loosely packed iridophores have spread beyond the first developing dark stripe, they again adopt the compact densely packed form and create a second light stripe. This process repeats itself until four light and four dark stripes have developed. The stripes therefore do not develop at the same time, but instead are created one at a time as the iridophores migrate and aggregate. The xanthophores, which are already in the skin, continue to divide and cover the growing skin with a network, loosely packed and branching over the melanophores and more compact over the iridophores in the light stripes.

Interesting questions about the properties of stem cells emerge from the observation of stripe development. Are there different stem cells for melanophores and iridophores? Which zones of the stripe pattern and how many cells of each type

One stem cell was marked in red on the first day of development so that we could recognize cells derived from it in the adult.

arise from a single stem cell? To answer these questions, stem cells were individually marked with RFP and their progeny followed during the whole stripe development process. This is called *clonal analysis*. The set of cells (here the differentiated pigment cells) that arise from a single cell (here the stem cell) is a clone. The contribution of a single stem cell can be seen as a red marking in the grown fish. This kind of analysis showed that a single stem cell can give rise to all three types of pigment cells. Additionally, nerve cells and their surrounding glial cells

are labeled; thus, they as well as the pigment cells arise from the same single stem cell. So stem cells are not dedicated to a specific cell type, but are *multipotent*. Individual stem-cell-derived clones have quite different shapes and contribute in variable degrees to the pigment pattern. No sharp boundaries can be seen between neighboring segments; cells from neighboring segments intermingle. On average, a single early established stem cell gives rise to all the pigment cells of one segment on one side of the fish. The clones that arise from the stem cell are quite variable in shape and size, and their increase in cell number, as well as their differentiation, is adapted to local circumstances. In this way it is assured that each of the three layers of the skin is populated appropriately with the three pigment cell types. The cells maintain contact with each other and seem to sense when something is missing.

It is really amazing that the populating of the skin with pigment cells requires no role from morphological structures such as stripes, scales, or fins. The stripes are not, as one might easily have imagined, defined by the direction of migration of the cells. The patterns develop completely independently of the origin of the pigment cell types.

Further questions arise from observing the development of stripes: what determines the spacing between the stripes? Are there morphological structures in the larva that serve as pre-patterns, as we have seen in the butterfly wing? Is there positional

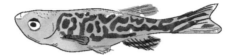

The horizontal myoseptum is missing in choker, and therefore also the orientation of the stripes, which form at random.

information? We have found a structure that directs the horizontal orientation of the stripes; the horizontal myoseptum that separates the dorsal and ventral muscle groups. It was a spectacular mutant, *choker*, in which the horizontal alignment of the stripes was lost, that revealed this. The mutant fishes develop meandering stripes that are different in every fish. This mutant was initially characterized as a muscle mutant in which the horizontal myoseptum was missing. As a consequence, the iridophores cannot use the myoseptum to reach the skin

first. They surface anywhere in the skin somewhat later. It is striking that the meandering stripes in adult *choker* fish are of normal width and arrangement. From this we can conclude that there is no invisible pre-pattern into which the three pigment cell types are directed. There also appears to be no morphogen gradient that provides positional information to cells of the skin. It also cannot be that the pigment cells first emerge mixed and then sort themselves out, because the melanophores scarcely move in the skin, but instead stay wherever they first appear. It seems likely that the pattern develops as a result of specific interactions between the three pigment cell types, which repel or attract each other in such a way as to end up correctly organized in the three overlying layers; in other words, they organize themselves. Consistent with this, no organized stripes appear in fishes in which one of the cell types is completely missing. In fishes that can make only one pigment cell type, the cells are distributed almost evenly and no pattern develops. The cell types thus need each other in order to make the pattern. Interestingly, only xanthophores and melanophores participate in stripe formation in the tail and anal fins, while the iridophores play a decisive role in the patterning of the body.

How can one imagine such self-organization actually working? Xanthophores and melanophores are cells with a richly branching structure, with extensions, ramifications, and filopodia with which

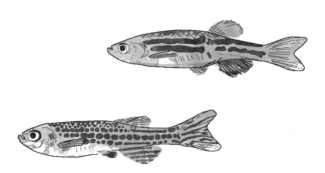

In Asterix the dark stripes are wide and irregular, while in schachbrett they form spots rather than stripes.

they contact each other. In this sense, they are like neurons, with which indeed they share a recent common ancestry from the neural crest. It is possible that processes take place at these contact points that are similar to the transmission of stimuli in the nervous system, or between nerve cells and muscles. Some hints about these processes have been provided by mutants in which the stripe pattern is not correctly displayed. In these fishes the stripes may be too broad or too narrow, completely absent, or in a spotted array. The molecules that are altered

or absent in such mutants belong to the class of membrane proteins, and are known to be involved in contacts between cells. Membrane proteins that form channels between cells and thereby allow the exchange of small molecules are, for instance, responsible for xanthophores adopting a compact, intensively colored form over the light stripe of densely packed iridophores. They also participate in the transition between the two states of iridophores that occurs as the stripes extend. Another channel protein influences the breadth of each stripe. We do not know much more about these processes; it makes an exciting topic for future investigation.

Evolution of Beauty

The origin of pigment cells from multipotent seg-
mentally distributed stem cells was only recently
discovered in the zebrafish and has not yet been
confirmed in any other animal. Probably the way
in which the skin is colonized by the three layers of

pigment cells in the zebrafish is the same in principle in all fish and possibly also amphibians and reptiles. The arrangement in stripes, and the different shapes of the pigment cells in the three layers, on the other hand, is absolutely specific to the zebrafish. Close relatives of the zebrafish (*Danio rerio*) look astonishingly different. The zebrafish belongs to the genus of *Danio* fish, a member of the large family of cyprinids (carp); European members of the family are the carps themselves, and the *Leuciscinae*, a group of closely related freshwater species, all of which are silvery; some species have red fins. In contrast, the related members of the *Danio* genus from tropical rivers are strikingly coloured and are much favoured by aquarium enthusiasts for their beauty. The pearl danio, *Danio albolineatus* is completely unstriped, while in other *Danio* species the melanophores make vertical dark bars. Some have dark spots on a light background; others have light spots on a dark background. In some species, the fins have an entirely distinct pattern, with striking red pigment, which makes them particularly attractive for us to look at (and perhaps also for members of their own species).

We can gain some important clues about the logic of pattern formation from this abundance of different patterns; the parallel stripes along the body occur only in zebrafish. This implies that the apparent periodicity of the pattern has no particular relevance to the mechanism by which they are formed. The pattern continuity between the body and fins

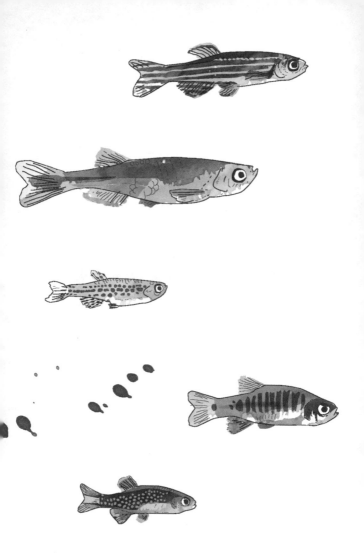

Closely related species have color patterns that are completely different from the zebrafish, some with brightly colored fins.

is also seen only in zebrafish, while in other species the fins are patterned differently from the body. The skin of the fins is structurally simpler than body skin, and it seems plausible that the distribution of pigment cells may also follow different rules.

The astonishing variety of color patterns in these closely related fish species shows how fast they can change during evolution. At the same time, the way of life and various morphological criteria have remained quite similar or indeed exactly the same. This also means that there are no favored geometrical patterns that are especially suitable for kin recognition. Rather, such patterns are arbitrary, but the fish must recognize them correctly to find the right sexual partner. How the fish know what they look like is not well understood; presumably imprinting plays a role, because they grow up in swarms with sibling fish that look alike.

These *Danio* species are so closely related that they can hybridize with one another, although the hybrids are not fertile. This means they must have very many genes in common. Genetic differences are possibly largely connected to their different color patterns. We are now looking for these differences by comparing the genes of differently patterned species. This should help us to identify candidates for more of the players involved in pattern formation. Two important methodological advances in genetics enable analyses that were impossible only a few years ago:

1. Genome sequencing, that is, the deciphering of all the genes of an organism. As recently as the beginning of the twenty-first century, this was extremely demanding and expensive, but today it has become a routine method, and increasingly refined and efficient data analysis allows comparison of the genomes of different species, as well as of single individuals of one species.

2. The method of gene-editing (the so-called CRISPR-Cas9 method). In the last few years, this has made it possible to cause targeted modification or elimination of gene function, including in zebrafish and its relatives.

We will use these methods to discover genetic differences between the species, and we can find out whether they have something to do with pattern formation by switching off candidate genes in the different species, or exchanging them between the species to see whether this causes corresponding changes in color pattern. In this way, we may be able to reveal the secret of exactly how such beautiful color patterns are made.

What have we learned through these investigations in the zebrafish that contributes to our understanding of color pattern formation? The goal of the research is of course not to understand in detail how the zebrafish gets its stripes, but rather to learn something about the principles of pattern development.

The zebrafish and its relatives are simply specific instances that allow general conclusions and hypotheses to be tested particularly elegantly by experiment. In fish, the uniform silver appearance of the skin due to reflective iridophores in a dense, unbroken cellular layer is the most important ancient function of pigmentation in protecting the body against UV radiation. Added to this is the dark coloration of the dorsal side, which makes the body shape hard to discern against the background by predators. Melanophores can absorb light of all wavelengths and therefore also contribute to protection against UV radiation. Where iridophores are excluded, patterns can arise. Thus we see in zebrafish how in those places where melanophores form dark stripes, the iridophores attenuate their dense layer and let the black of the melanophores shine through, blue-tinted by reflection in the remaining iridophores. The xanthophores are concentrated over the dense iridophore layer and give it a golden hue.

We learn from the great variety of color patterns of closely related *Danio* species that there is no standardized morphological pre-pattern that provides a basic framework, and also no long-distance signaling gradients arising at the edges of the patterns. In the zebrafish, the horizontal myoseptum is as it were exploited to orient the stripes, but this is a special case because other patterns do not use this feature. Thus the melanophores of the vertical bars that occur in some *Danio* species, and in many other fish,

possibly reach the skin by following the vertical tracts and branches of the segmental peripheral nerves. In other fish species, it may be that other morphological structures play an analogous role, such as the dorsal rim or the margins of the scales. Red and yellow colors provoke sexual arousal in many animals: we find this coloration from xanthophores layered above the light background provided by the iridophores, or, in some *Danio* species, in the fins.

In zebrafish as well as in other *Danio* species, the pigment patterns function as social signals enabling recognition within species. The patterns are restricted to the flanks and fins with the exception of the pectoral and pelvic fins, while the back,

Horizontal and vertical stripes are common motifs in the ornamentation of birds and mammals.

belly, and head are not patterned. This implies that the rules of interaction between the pigment cells depend on the local environment and not only on their specific cellular properties, and that the environment in such regions affects the interaction between the pigment cells. Many fish species have striking color patterns on their flanks, and as in the case of the *Danio* species, vertical or horizontal stripes are common decorative motifs. We suggest that what we have learned from zebrafish can also explain these patterns.

Mammals and birds have only one type of pigment cell, the melanocyte. Nevertheless, they also may display fascinating color patterns whose

beauty at least matches that of the fish. Especially in birds we find the most unbelievable colors, textures, and patterns, but we know essentially nothing about how these come about. In fact, it is difficult to imagine experiments on such animals that might contribute to the clarification of mechanisms of pattern formation. These species lack all the advantages of the zebrafish as an experimental animal: the accessible development outside the mother's womb or the bird's egg, the ability to make continuous microscopic observations on the living animals, the ease of genetic manipulation. We are therefore forced to speculate, but the knowledge about the development of stripes in zebrafish may guide us.

Vertical and horizontal stripes are found in some mammals; examples are tigers, zebras, striped squirrels, and young wild boars. In these stripes, the hairs are alternately light or dark. The patterns are reminiscent of the commonest fish patterns and suggest a similar origin. Perhaps here there are different kinds of melanocyte, producing melanin of different intensities. A mutant of the tiger, the white tiger, has a defective gene known in zebrafish as *albino* because the melanophores produce no black pigment. In white tigers it is only the light brown, but not the black stripes that are affected. This shows that there are two kinds of melanocytes at work that, possibly through self-organization and mutual interactions, as in the zebrafish, can produce cleanly separated stripes, but also spots or rings as in

leopards. Perhaps these have different developmental origins. Till now, it has been assumed that the precursors of melanocytes in mammals and birds only take the external route before spreading in the skin to colonize the hair follicles and feather roots, like the xanthophores of fish. But there is new evidence that melanocytes also arise from stem cells together with the peripheral nervous system, and reach the skin through the inner route. Vertical stripes could then arise if pigment cells spread along the segmental peripheral nerves, as shown for the individual clones in zebrafish.

Another question concerns the relationship between the pigment cells. Basal vertebrates have three pigment cell types; where did they come from? Were iridophores first, or melanophores? Melanin is a pigment that is also extremely widespread in bacteria, plants, and fungi, suggesting that melanophores came first.

Guanine, the compound that creates the bright silvery appearance of the iridophores, is one of the building blocks of nucleic acids and a major component of guano, the excrement of sea birds that has been used for centuries as a valuable fertilizer. Were iridophores originally used as a disposable means of detoxifying the body through the skin, then repurposed as they took over the function of protecting the skin from UV radiation? Did the iridophores get lost on the evolutionary route toward birds and mammals, or did they "learn" to produce

melanin? Nanostructures in feathers and hair can appear white, shiny, or iridescent, thus making iridophores superfluous. Perhaps the melanocytes of birds and mammals that migrate from the neural crest to the skin via the inner route arose from the iridophores. The same signaling molecules, so-called endothelins, that are required for the growth of iridophores in zebrafish are required for melanocytes in mammals, arguing for a close relationship between the two cell types. What is the function of the xanthophores? Are they simply there to create variety in external appearance, and therefore purely for beauty?

Perhaps some of these questions can be answered in other species through the new methods of genetic analysis. But how the peacock does it will surely still be a mystery far into the future.

The greatest happiness for an intellectual being is to have researched what can be elucidated by research and quietly to venerate that which cannot.

Johann Wolfgang von Goethe

Acknowledgments

Thank you to friends and colleagues who contributed through discussions and suggestions to this essay. For thorough reading, editing, and commenting on the various drafts, I am obliged to Berenice Schierenberg, Siegfried Roth, Uwe Irion, Julia Fischer, and, above all, Jana Krauss.

Suggested Reading

Darwin, C. 1859. *On the Origin of Species by Means of Natural Selection, or The Preservation of Favoured Races in the Struggle for Life*. London: John Murray. (Oxford Classics, 1996.)

Darwin, C. 1871. *The Descent of Man and Selection in Relation to Sex*. London: John Murray. (Penguin, 2004.)

Fischer, J. 2012. *Affengesellschaft*. Berlin: Suhrkamp.

Howard, J. 2001. *Darwin: A Very Short Introduction*. Oxford: Oxford University Press.

Lorenz, K. 1967. *On Aggression*. London: Methuen.

Meinhardt, H. 1995. *The Algorithmic Beauty of Sea Shells*. New York: Springer.

Nüsslein-Volhard, C. 2006. *Coming to Life: How Genes Drive Development*. New Haven: Yale University Press.

Nüsslein-Volhard, C., and A. Singh. 2017. "How Fish Colour Their Skin: A Paradigm for Development and Evolution of Adult Patterns." *Bioessays* 39: 201600231.

Portmann, A. 1956. *Tarnung im Tierreich*. Berlin: Springer.

Protas, M., and N. Patel. 2008. "Evolution of Coloration Patterns." *Annual Reviews Cell Developmental Biology* 24:425–446.

Prum, R. O. 2013. "Coevolutionary Aesthetics in Human and Biotic Artworlds." *Biology and Philosophy* 28:811–832.

Prum, R. O. 2017. *Evolution of Beauty: How Darwin's Forgotten Theory of Mate Choice Shapes the Animal World—and Us*. London: Penguin Random House.

Tattersal, J. 1999. *Becoming Human: Evolution and Human Uniqueness.* New York: Houghton Mifflin Harcourt/Mariner Books.

Tinbergen, N. 1965. *Social Behaviour in Animals.* London: Chapman and Hall.

Tomasello, M. 2014. *A Natural History of Human Thinking.* Cambridge, MA: Harvard University Press.

Wyatt, T. D. 2017. *Animal Behaviour: A Very Short Introduction.* Oxford: Oxford University Press.